EVOKE

The Digital art of Angel

**Dedicated to the memory of those whose journey ended.
To family and friends lost but never forgotten.**

ANGEL ILLUSTRATIONS

Copyright 2013 by Karl "Angel" Lines.

The book author retains sole copyright to his contributions to this book. All models featured within these pages have given permission for reproduction of their work in printed form, any unauthorised copying or redistribution of any work within these pages will be prosecuted to the fullest extent of the law.

And we will set the Hamster of doom on you.

A Message from the artist.

So where were we? Well to recap the last 3 years since the release of Forever: The art of Angel:

I hosted a charity exhibition for Welsh Women's Aid, saw my artwork on the covers of two CD releases, shortlisted for two major art awards but most significantly I was medically advised to cut back on my caffeine intake!!!

Tragedy of the caffeine aside, the past three years has not been its kindest, I lost family, friends, my day job and almost my sanity. I saw dreams snatched away from me, plans devastated and never quite understood how much a life can adapt and bend in the face of trouble.

Yet we carry on, and carry on we jolly well have.

Well, the final sections of Forever: The art of Angel (if you haven't read it, find a copy, it's a fascinating read and a great way to while away a lengthy bathroom break) a new chapter was unfolding, where a seed of a photographer was planted, an ugly stinging nettle of a photographer grew.

Before I was relying on stock images, friends and the kindness of strangers, now I can take my DSLR and grab a shot that matches my ideas and develop my painting from scratch, and if I am honest I enjoy it. I do however allow myself a moan at the complexity of my ideas, the regular and painful appearance of The Claw ™ and that I now find myself spending upwards of 100 hours on individual pieces so it isn't completely different to normal service.

So what are you going to find within the pages of Evoke? Pretty paintings, certainly some idiotic rambling, in jokes, self depreciating humour but most importantly you will get to see the evolution of the artist, the hours and experimental techniques employed in every piece, a few photographs here and there and the labour of love that lies within me.

Remember, I don't take myself seriously and neither should you, sit back, read on and enjoy Evoke.

I'm on a horse.

"The painter has the universe in his mind and hands."
— da Vinci

Since being asked by Karl to write an introduction to Evoke, I've wondered what it is that draws me to his creations. The hours of work, driven by his obsessive attention to detail, serve to create some of the most wonderful and fantastical art I have seen. Recalling our first meeting in Swansea, I remember his surprise when I compared his work to that of Michael Whelan. Yet I stand by that as Karl's work continues to wow me, each new piece offering a glimpse of an artist's imagination that is bursting with life.

As a photographer I work to capture the essence of a moment, be it on the streets, in nature or in the studio. Karl's work is to create a moment, not in time but rather in the imagination. With as much as 140 hours of work going into a piece, this is a labour of love as every detail, be it hair or key, is individually rendered.

In a recent conversation, Karl mentioned, "I'm finishing this portrait...this one makes [that] painting looks like a crayon sketch. I'm struggling because I can't stop it looking hyper real." My response was to let it be what it wants to be, for as George Bernard Shaw said, "Without art, the crudeness of reality would make the world unbearable."

Karl's imagination has soared in recent times, each piece a chance to step away from the humdrum of normality into other worlds. Imagination has taken a battering over the last twenty years, stifled by an instant technological diet of film and console based fantasy, but as Jung said, "All the works of man have their origin in creative fantasy. What right have we then to depreciate imagination." Karl's work serves to redress the balance.

On a personal note, I've had the pleasure of knowing Karl for almost two years and of working alongside him on a number of projects, finding him to be one of those genuinely nice guys you read about but rarely meet.

Ceri Vale

These images are all portraits, painted over a 9 month span in 2013.

They all feature a lock, a key or both.

There is a reason as to why I chose that theme, there are reasons behind the colours, the poses and the titles.

It is up to you, as the viewer, to find them and link them.

This was my journey, now let it become yours.

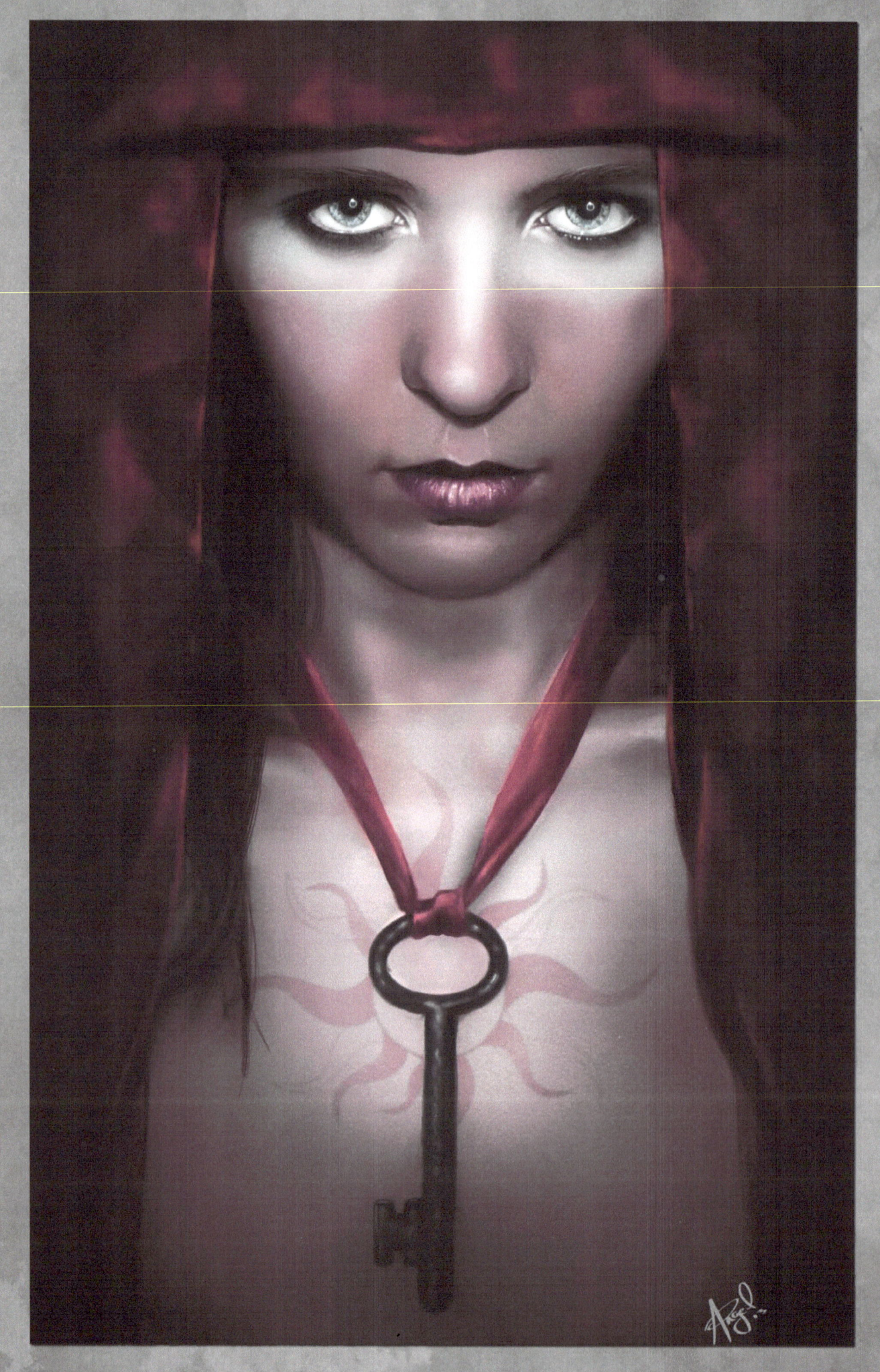

Deadhead

Really the best place to start in any journey is at the beginning and Deadhead truly is the beginning of this one.

Way back before Evoke was even a project there was an idea, an idea to paint an image that would make people stop in their tracks and involuntarily stare at it.

That was the plan at any rate.

Born in November 2012 this scattered idea took almost 3 months to actually create until it was virtually screaming for my brain to release it. So I borrowed my friend Chazz, duct-taped a halloween costume to her head and said "let me do my thing".

It then took me another 3 months to actually paint up but when I finished, boy did I have a smile on my face.

Model: Chazz

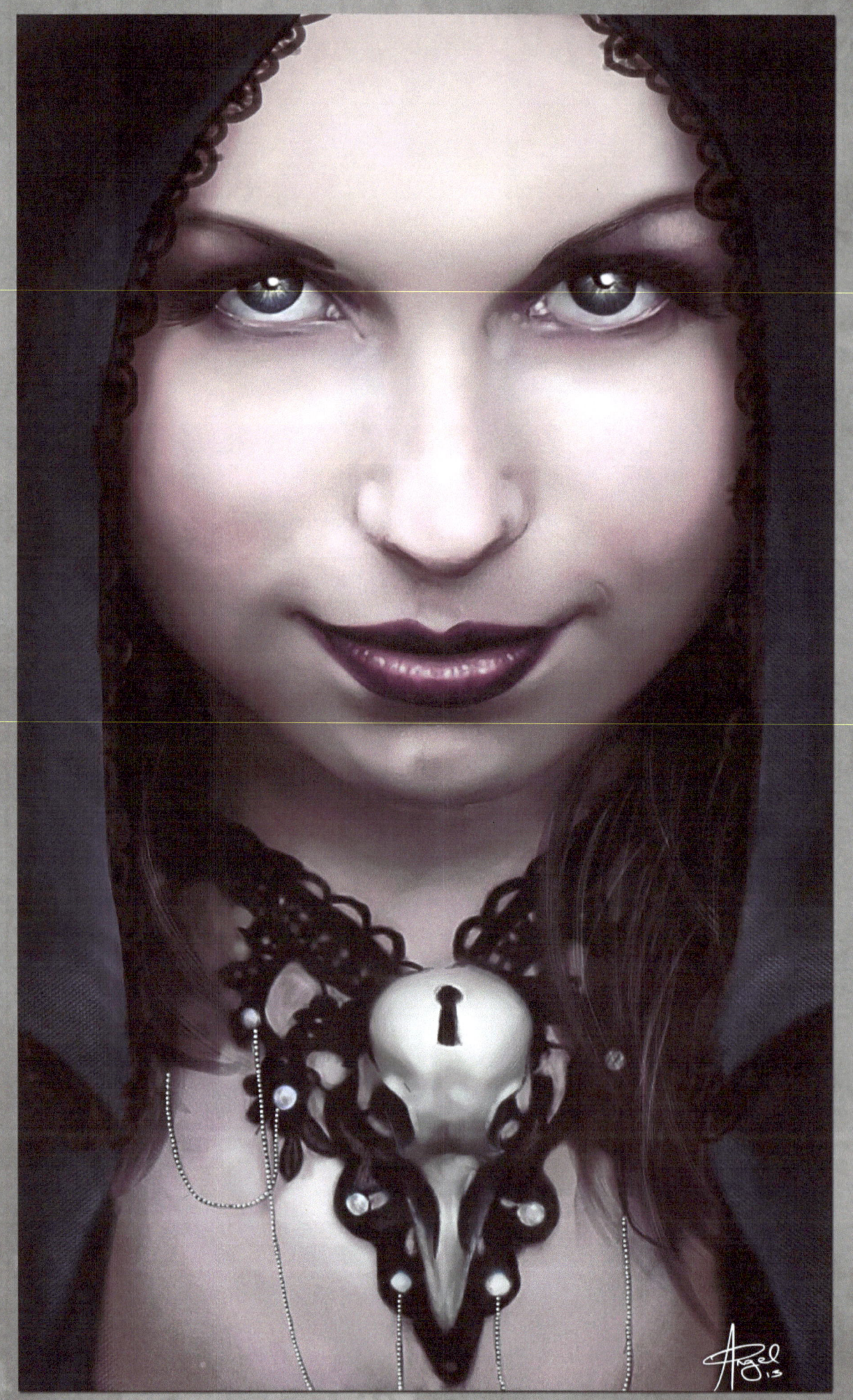

Kingdom

Even when this was taken Evoke was still not an idea; I had not even painted Deadhead, but I was still photographing and working on other things.

I shot with Jodie and her boundless, unrelenting energy at an abandoned and crumbling church close to Tintern Abbey just for fun really, it became known as the "Jodie in an 'ole" shoot.

This painting was started within hours of Deadhead being completed; I had enjoyed the simplistic nature of just a portrait so much that I wanted to do another one, and this was the result.

This is really the point where my brain went "You know, you could do some more, one or two no more than that. Go on... you know you want to!"

And you know what, I did want to.

Model: Jodie Nicole
Jewellery - Hysteria Machine
Hair - Lucy Purrington hair.

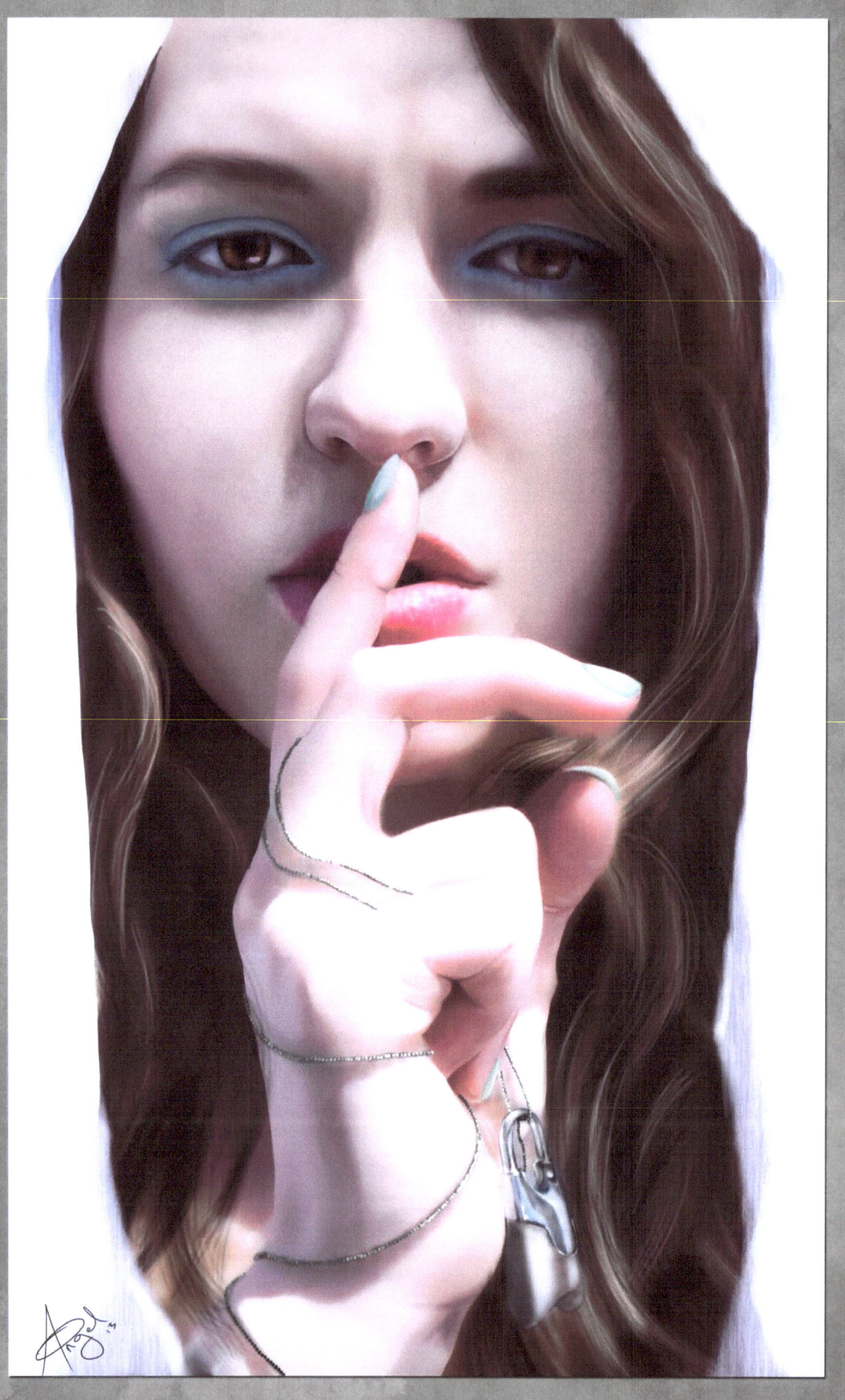

Ghost

I had made a conscious choice at this point to do a couple more. I put out a casting call to see what happened and got slightly overwhelmed with the replies.

I had actually planned to work with Amazon Alice before but time, ideas and schedules never quite matched up.

So I booked two shoots and headed off to Aberdare for the day.

Ghost was the first shoot of the day: light, bright and very different to my usual style of low, muted colours and took no more than 10 minutes, much to the surprise of the model. Of course this left me and my thoughts ticking over for the day, and a thought started nibbling at me in those hours that this whole portrait should become something a little more.

Model: Amazon Alice

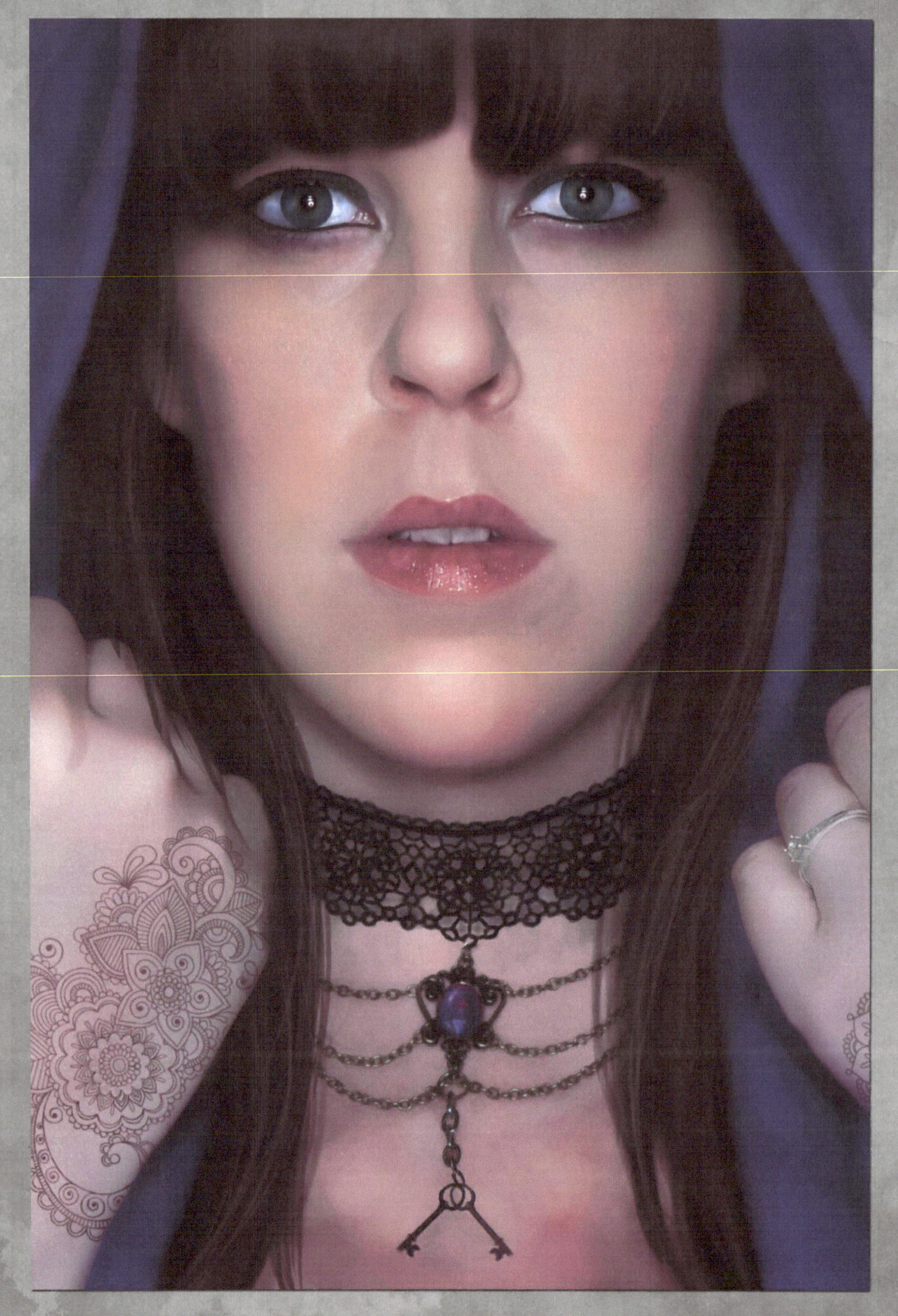

Storm

I have a superstitious streak about a mile wide, I believe in signs and portents more than black cats and broken mirrors, so in the hours between Ghost and Storm I began to see signs. My website logo was perfectly formed in the grain in wood panelling, I saw my lucky animal and everywhere I looked I saw more signs, so naturally I wanted to do a little more.

I think I can say with absolute certainty that this image had two important roles to play in the development of Evoke.

Firstly, painting that much lace and a mendhi hurts your RSI; secondly, this was certainly the idea that turned Evoke from a footnote into an opening paragraph.

Model: Jenna Lou.

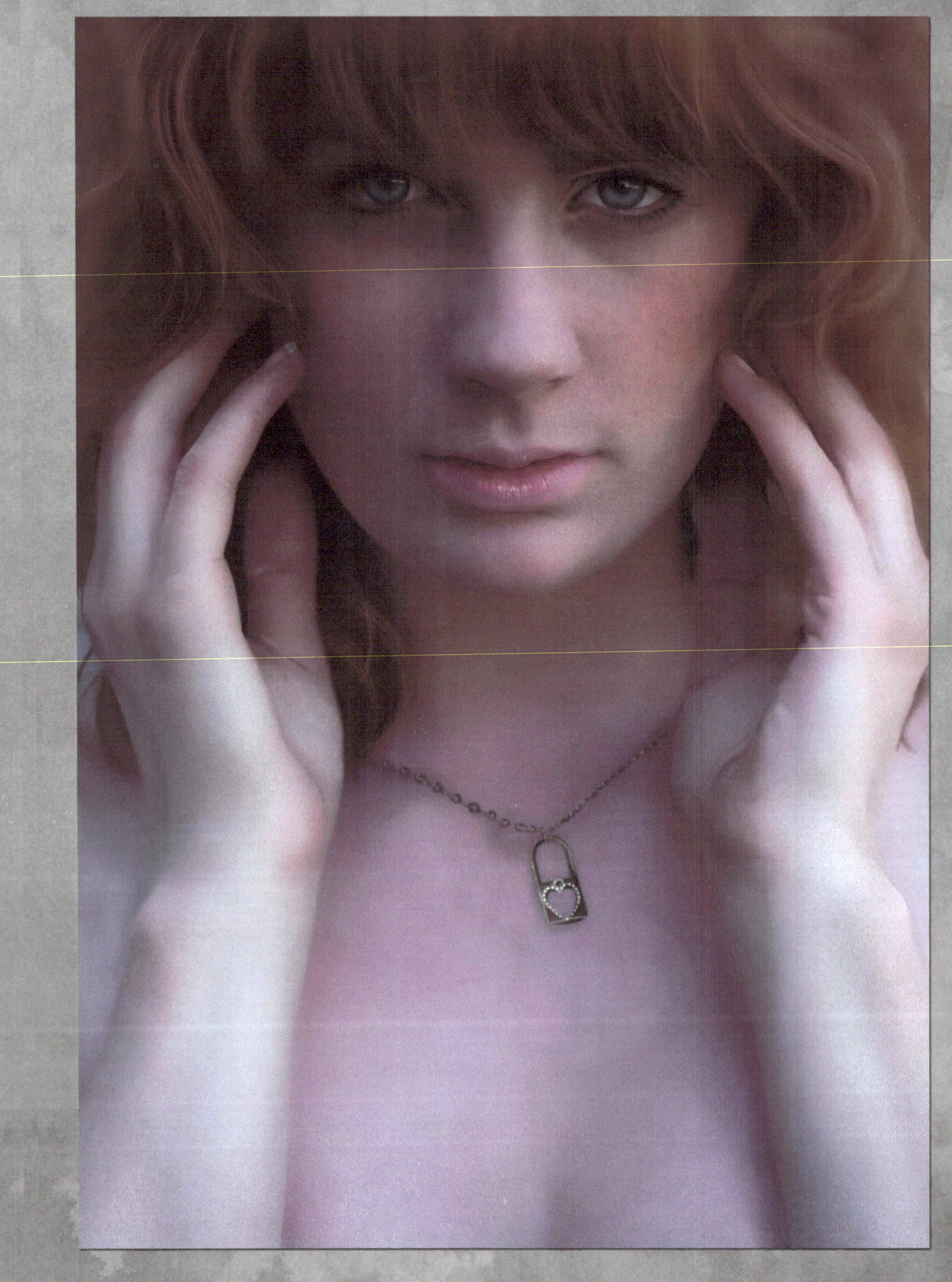

Feather

If Storm was the point where the idea became the opening paragraph, then Feather was certainly the headline.

I had originally booked Artemis for two hours and saw my original plans vanish due to slow delivery of a prop and made me work on the fly for the first time in this project.

I had to use a different necklace, which meant that the idea was needing to change on the day.

Would this image have been as good if I had used the original props? Gone with the original pose and idea? I cannot answer that, but what I can say is that this was the point where I needed a massive positivity boost, and by jove I received it.

This shoot, this painting, brought the whole project to life.

Model: Artemis Fauna.

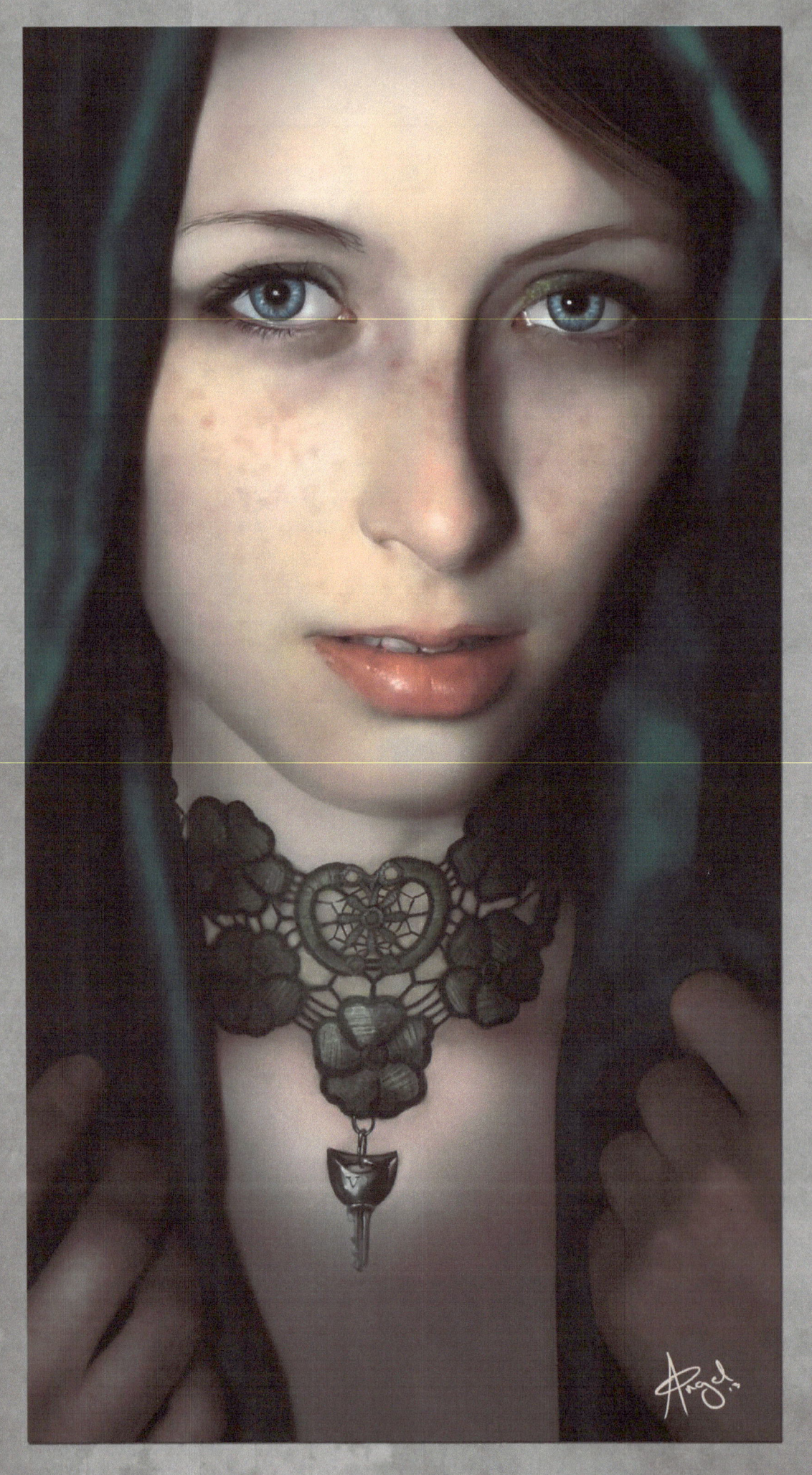

Gaia

In my infinite lunacy I took a weekend and booked 3 shoots in 2 different cities involving over 150 miles in travel; of course by now I had already turned Evoke from a small side project into a full blown exhibition and book option.

Shooting in an underground car park in a building somewhere in Cardiff was very different to normal, but what really was strange was my return to painting lace after the pain of Storm, a lesson I was not to learn too well sadly.

In a unique point, this was one of the first times I've actually painted with a predominant green colour and not struggled, yay me.

Model: Alex Kathryn

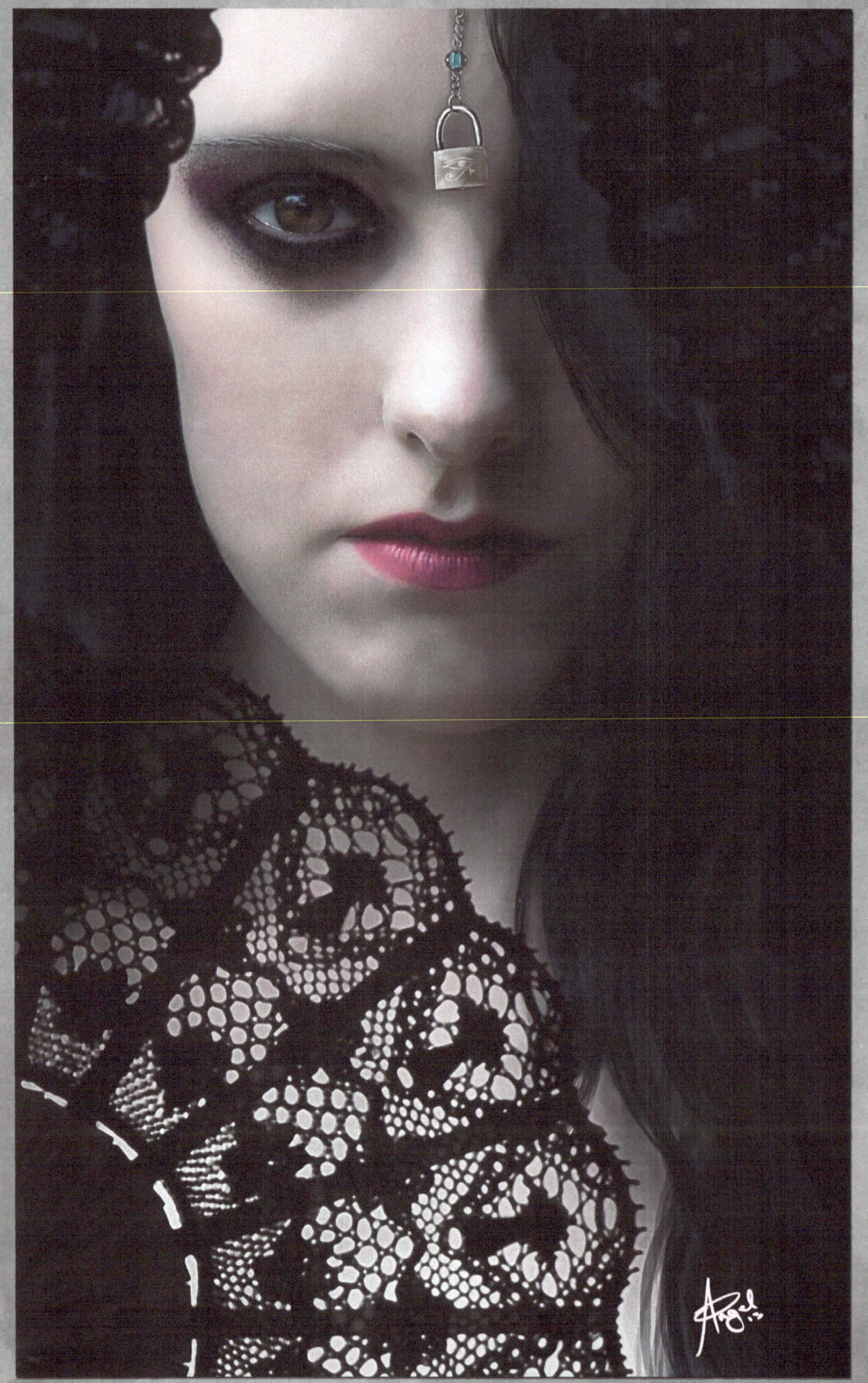

Terminal

A quick lunch and I dove straight in to shooting with Becca.

The plan was to walk to a park in Cardiff, take the shots and head off to relax before my shoots the next day, but like Feather showed me: plans often go awry.

I actually forgot where the park was but luckily found another park to use, and an improvised necklace made of department store chain and a padlock was required.

Otherwise known as "messy haired girl in the park" at the model's request, Terminal really taught me a lesson that lace bad, hands good.

Model: Becca Brown

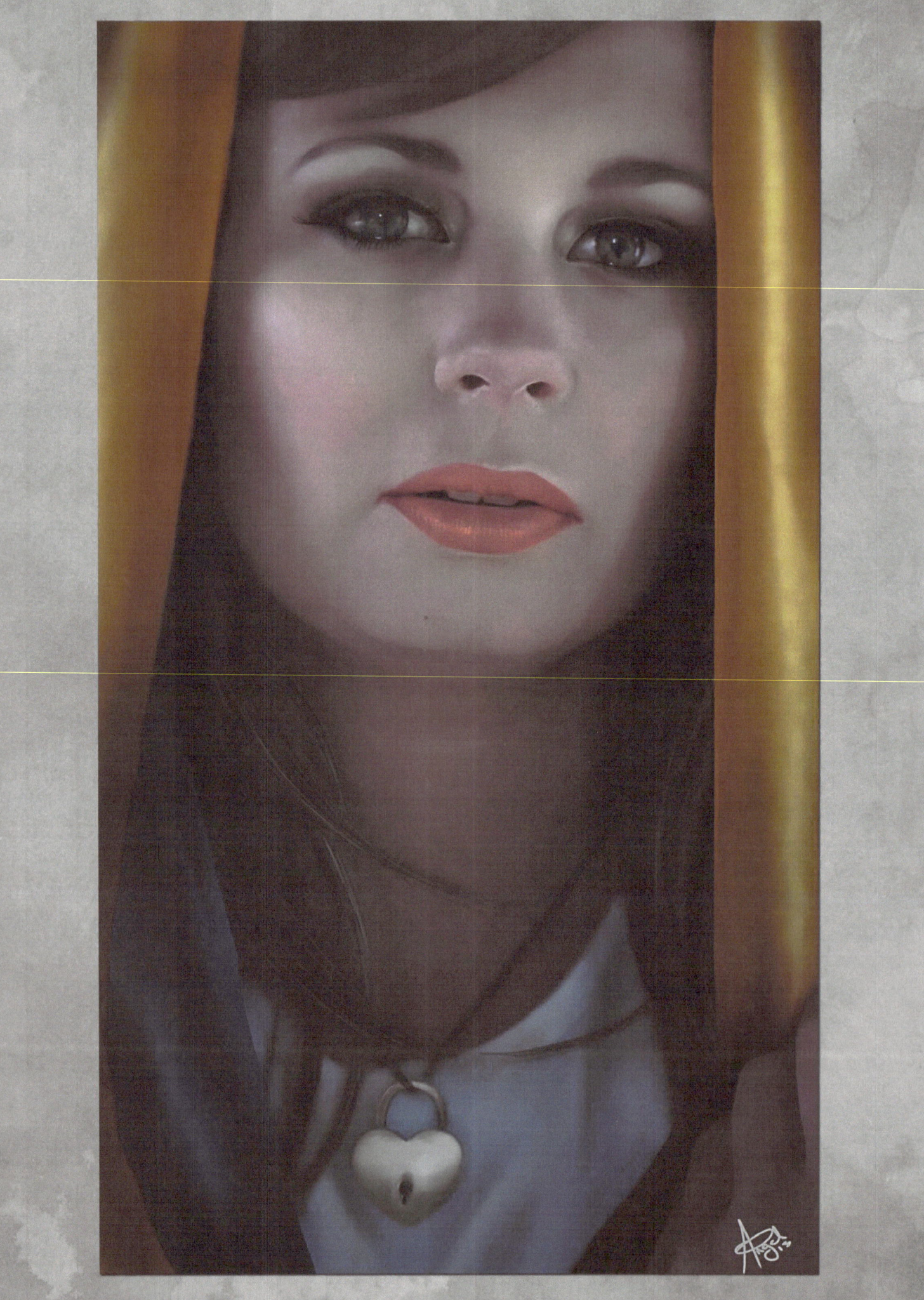

Grace

Dita was fun. A huge, passionate, energetic, enthusiastic bundle of energy that I barely managed to keep up with on a very rainy day in Newport.

Having more enthusiasm for my artwork than I had was unique, and even if I was at full strength, caffeinated and sugared up I would have struggled hard, but it was great to see a sunny disposition on an otherwise terribly rainy day.

Another bright note, there was no lace in this piece.

Model: Dita
MUA: Sorrell Brown.

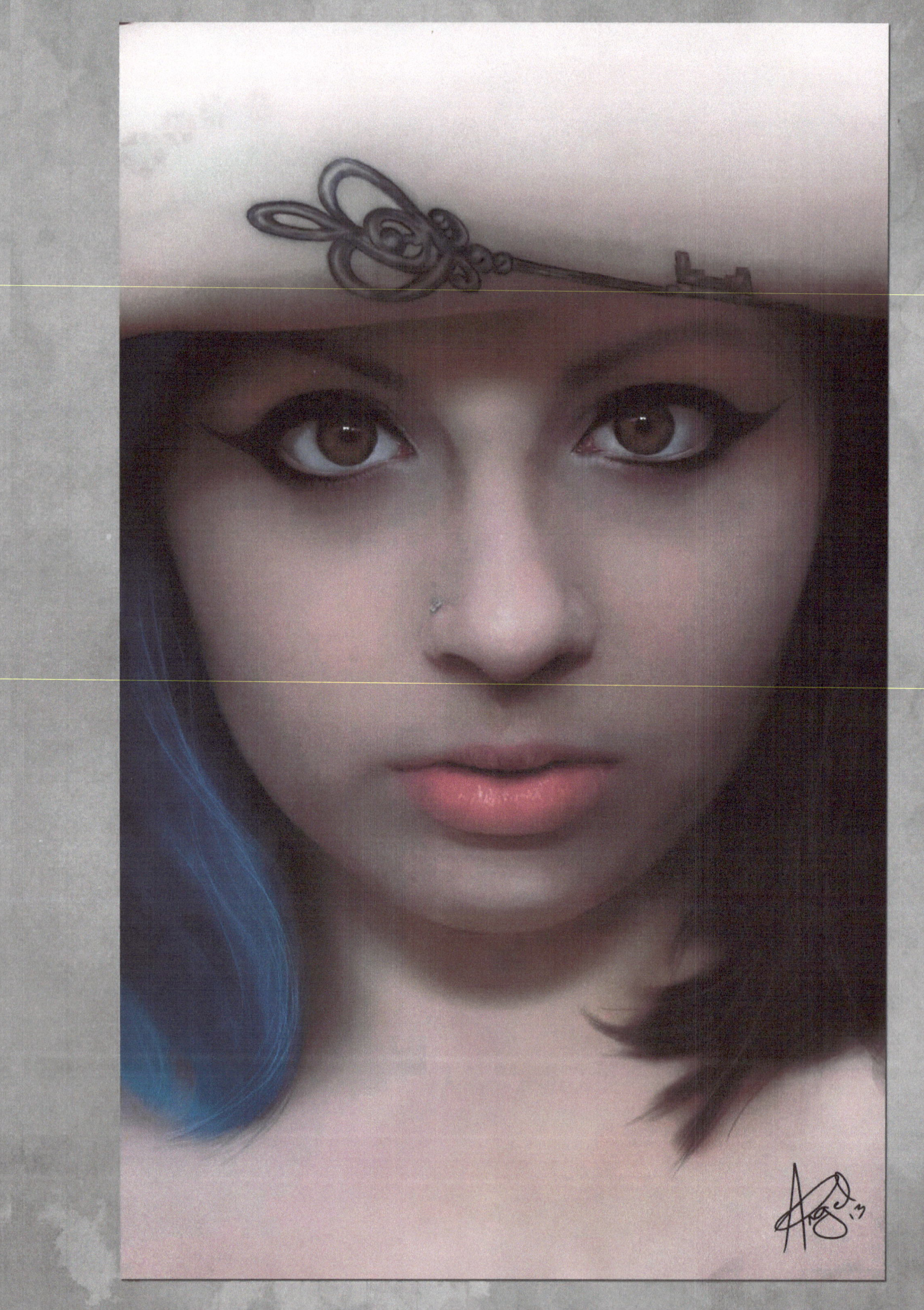

Truth

Serendipity:

1. The faculty of making fortunate discoveries by accident.

2. The fact or occurrence of such discoveries.

3. An instance of making such a discovery.

What are the odds of finding a model who has a mad fetish for keys and locks and key tattoos when you are working on a project that is featuring both Keys and Locks in the artwork?

When you find out those kind of facts, you move heaven and earth to incorporate that key into the finished work, I should be grateful that the key is on the inside of her arm and not beautifully etched elsewhere on her person.

Model: N. Vanity.

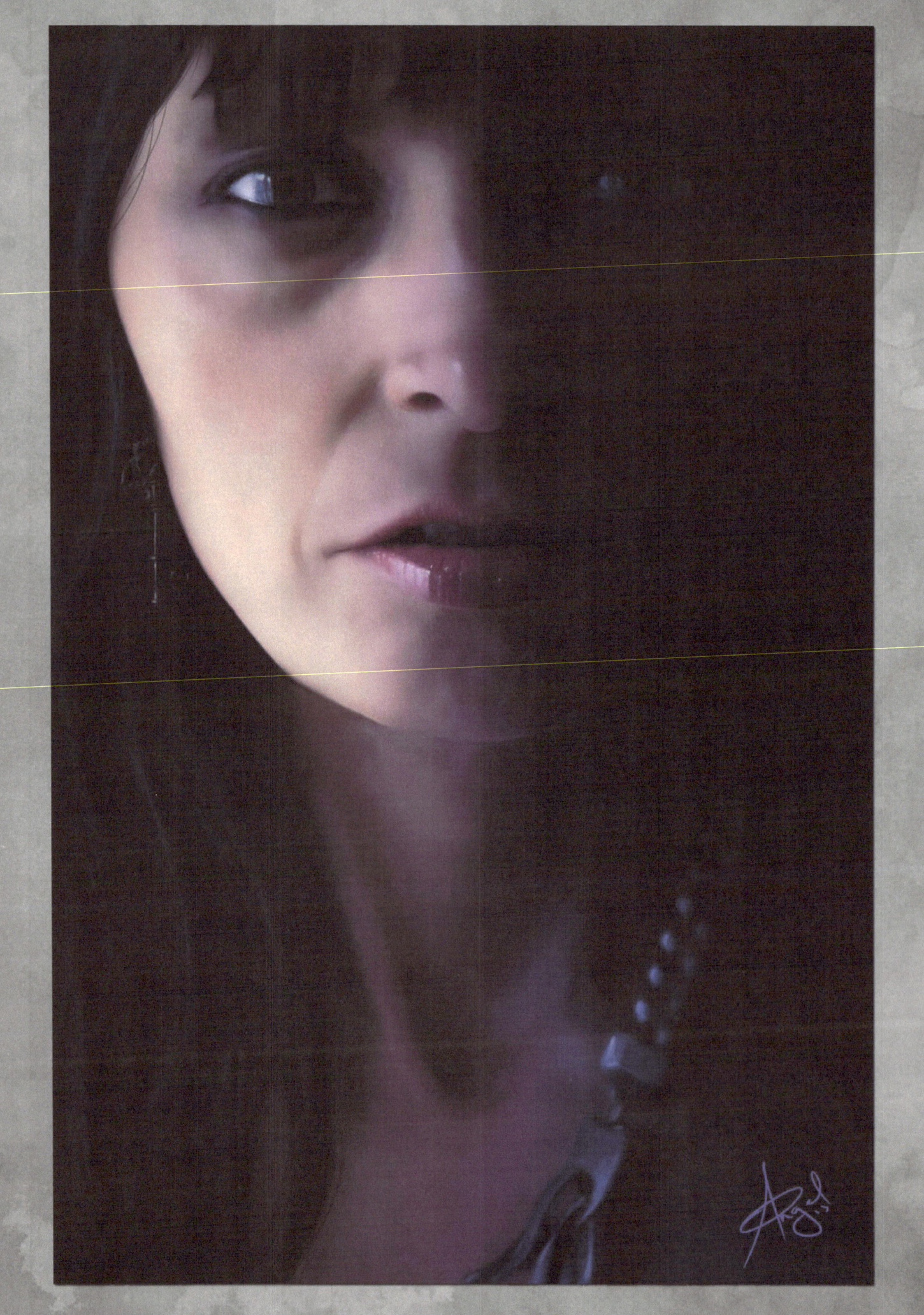

Judgement

A beautiful, balmy hot saturday in Bristol quickly changed into another one of those "let's adapt on the fly" shoots when it became a Stormy, rainy afternoon in Weston Super Mare.

Of course being from Wales meant that whilst everyone else was diving for cover from the heavy rain, I was merrily walking through it at slow space, silently happy to be in natural weather (hot fiery orbs in the sky are relatively rare occurrences in Wales).

Akasha met me at the station and did what every model should do when they meet me the first time - feed me scones and coffee!

Of course the unexpected rain meant that the original location of a castle was now unusable. So bundled back into the car, a quick trip through the wilds of Weston ensued to a drier place where I realised that I had completely forgotten her Key.

Improvised shooting became second nature to me at this point. Butwhen you are having fun and discussing dinosaur cars, you tend to not panic so much.

Model: Akasha

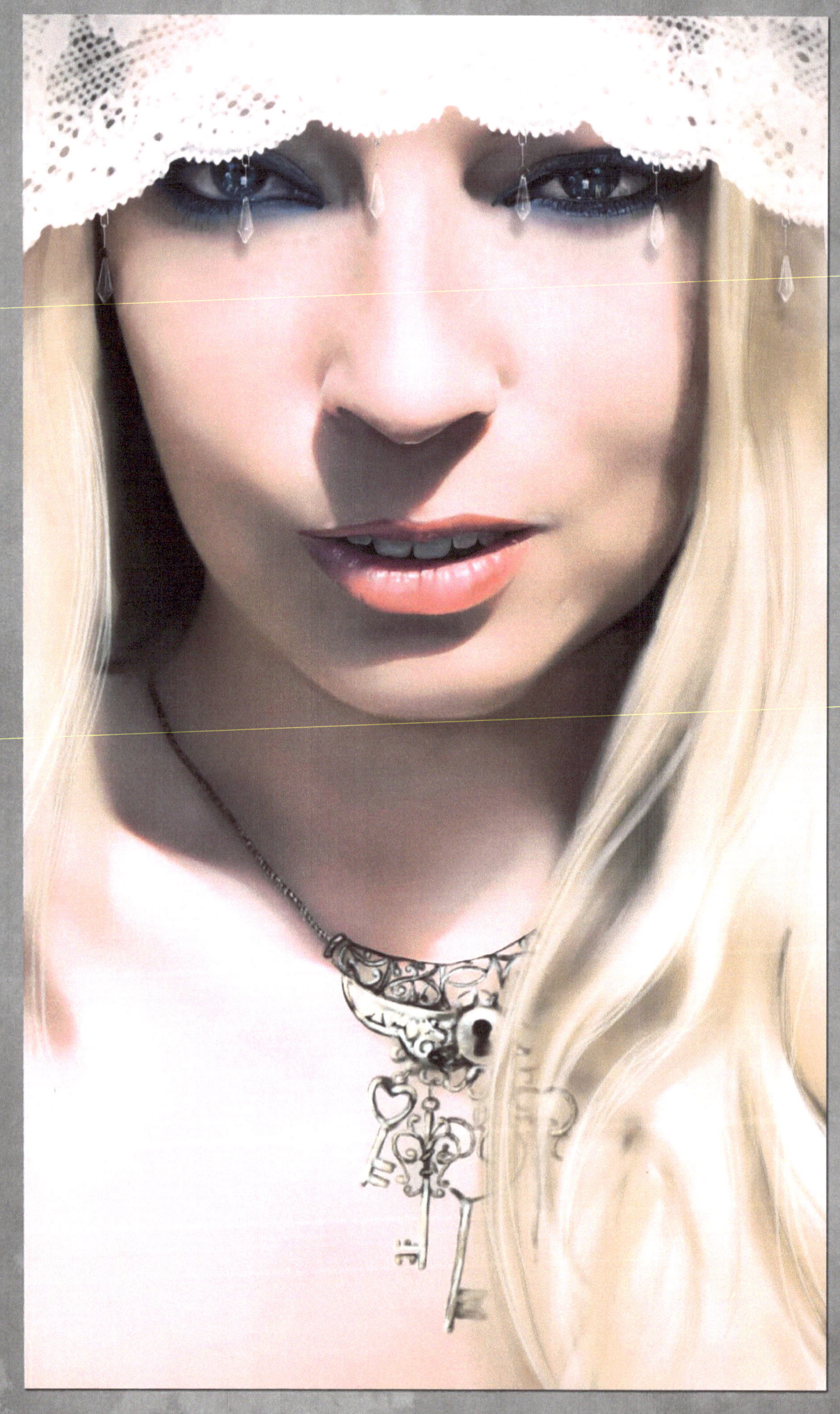

Infinity

A two day round trip to Oxfordshire, a necklace that arrived too late and a photoshoot inside a church.

Surreal - yes; fun? Absolutely.

Model: Kelle

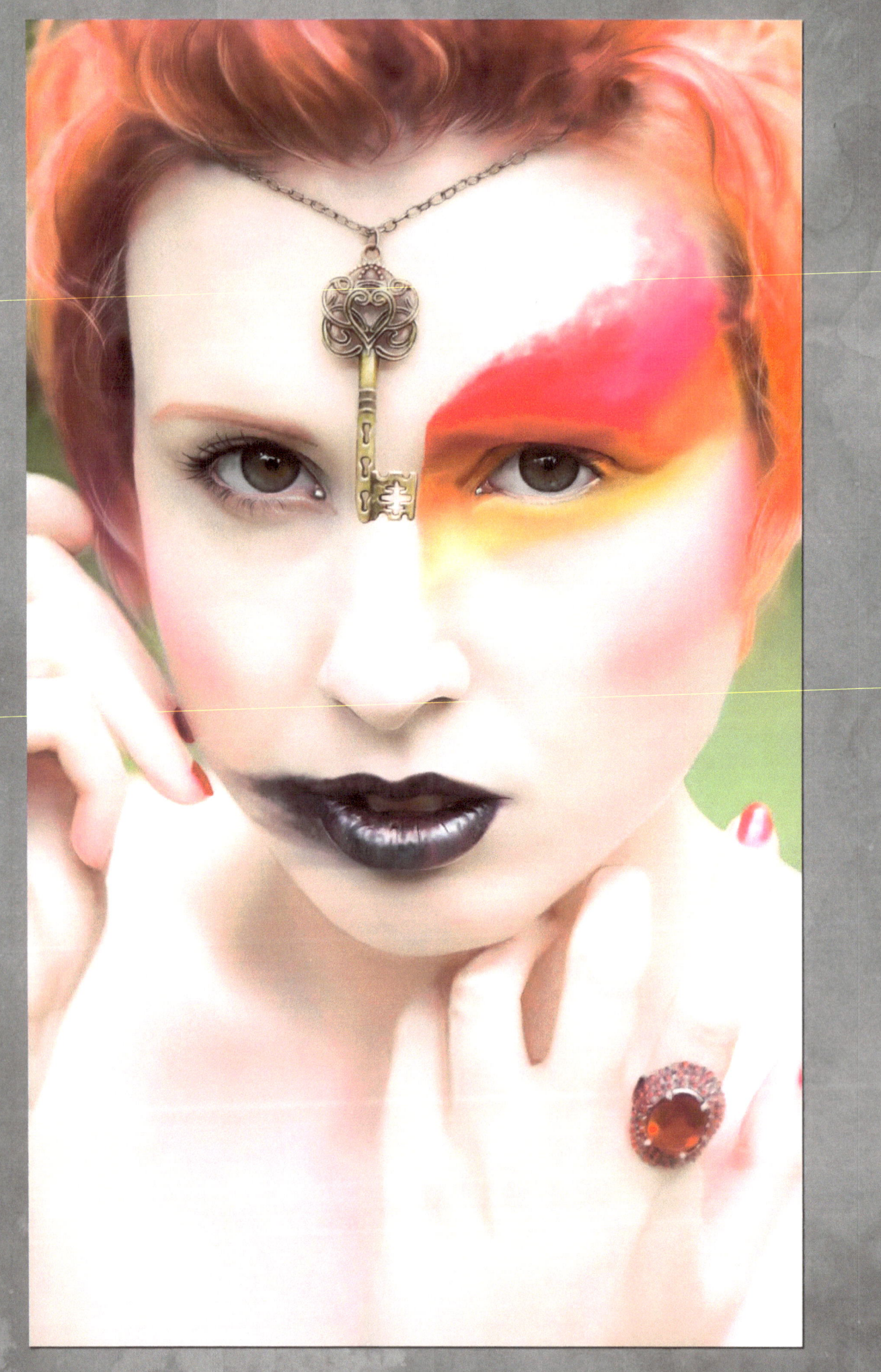

Sunset

On my last big project, the first image I took was of Lisa, so it was just written in the fates when she volunteered to model for me on the Evoke project, and simply perfect that this painting was the last one created for Evoke.

Memory of a soul has a way of taking the bare bones of an idea, wrapping her imagination around it and coming to the shoot with ideas you never knew you wanted, so it is no mystery why I enjoy shooting and working with her so much.

Not to mention that the shoot took place under the gaze of two of my lucky animals who promptly flew away when the shoot was complete.

So that was the end of Evoke, and it has to be said that it was a day of mixed emotions. After almost a year in unknowing development, 13 models in 7 Cities, close to 700 miles of travel I did not want it to end, but end it had to.

But then with every journey's end, there are a 100 new ones ready to travel.

And that's the end of my story.

Model: Memory of a soul.

SKETCHES AND NOTES

The following are a small collection of sketches, notes and assorted nonsense.

I keep notebooks of everything I do, so this is a rare insight into my genuine thought process for a few of the images.

Alex - Eva green.

Ray!

So pale tone it down.

again with the lace. no needle this time.

also lear of Mask.

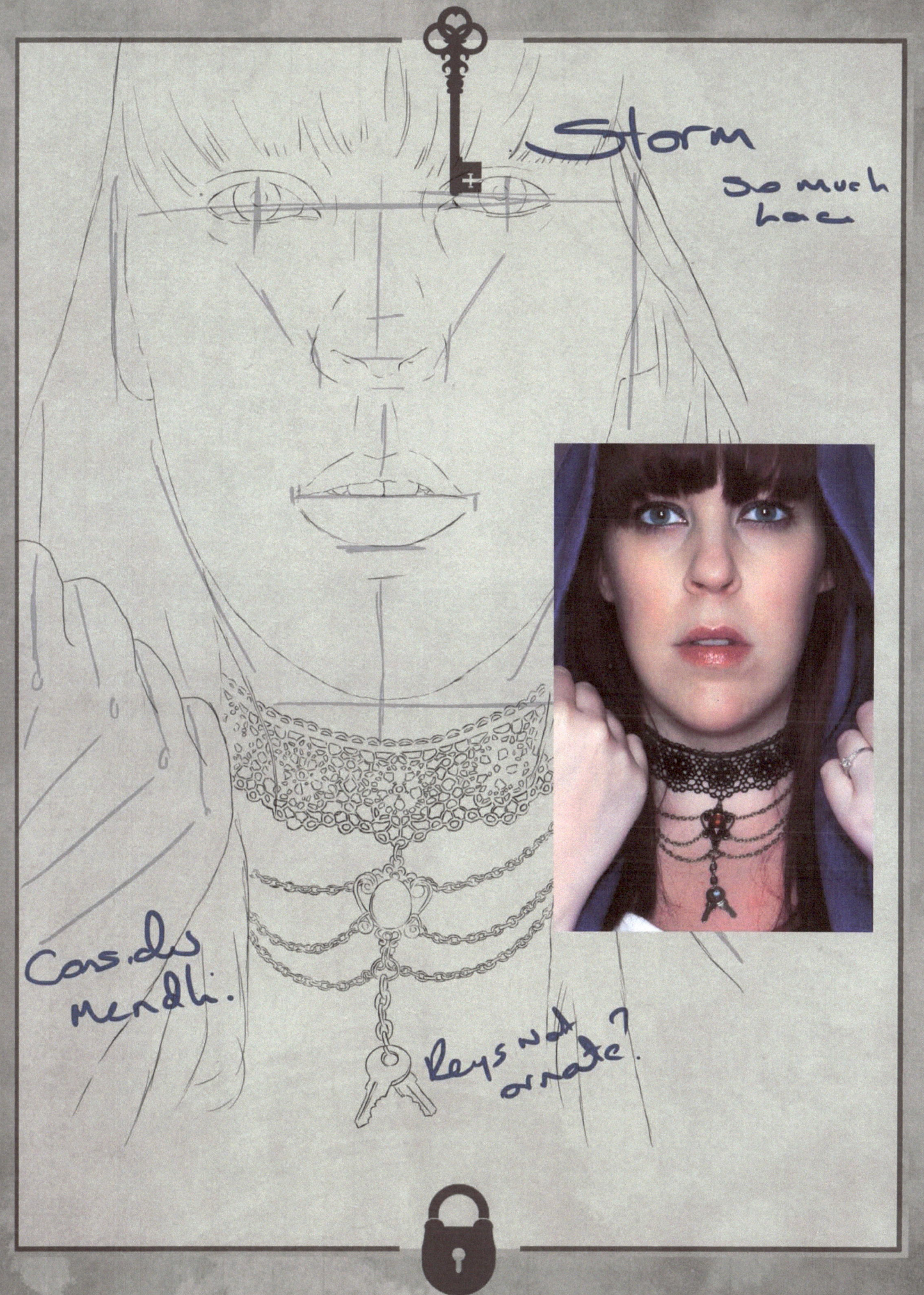

Ghost
"speak no evil"
Amazon Alice

Shhh

Padlock
for locked
"silence"

white + light
colours.

ARTEMIS wear NOEV.1' feather

change from original idea! use lock.

Try to take a focus image once in a while

So, that was my journey.

I do hope you enjoyed the work enclosed in the pages of this release, be it because you visited the exhibition and wanted to own the book, a long term fan who bought the book for Christmas or because you have found it in the fractured and crippled remains of the old world after a zombie apocalypse. My aim with this work was to strip my artwork back to basics, remove the dramatic theatrics that everyone loved and expected from me and leave the art behind.
I hope I achieved this.

So where to from here? Where does my journey take me? Well my creativity knows no bounds, and even before I had completed all the work for Evoke I had began work for my next series. Combining all the things I learned from Evoke and mixing them back in with the explosive drama of my usual work.
It is something to keep your eyes open for.

Until then, thank you for reading, thank you for your support and thank you for sticking with me.

Visions

Forever: The Art of Angel

Evoke 2014 Calendar

Tshirts, Calendars, Posters, Postcards, iPhone and iPad cases availeble on
www.angelillustrations.co.uk

www.ingramcontent.com/pod-product-compliance
Lightning Source LLC
Chambersburg PA
CBHW051108180526
45172CB00002B/820